NATIONAL NATIVE AMERICAN VETERANS MEMORIAL

A SOUVENIR BOOK

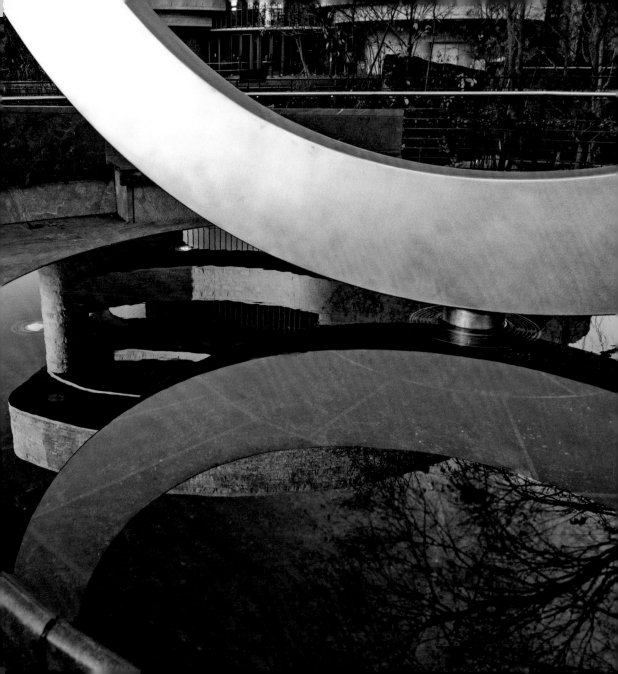

NATIONAL NATIVE AMERICAN VETERANS MEMORIAL

A SOUVENIR BOOK

Smithsonian Books

In Association with the National Museum of the American Indian
Smithsonian Institution
Washington, DC, and New York

The Smithsonian's National Museum
of the American Indian

VISION
Equity and social justice for the Native peoples of the Western Hemisphere through education, inspiration, and empowerment.

MISSION
In partnership with Native peoples and their allies, the National Museum of the American Indian fosters a richer shared human experience through a more informed understanding of Native peoples.

For more information about the museum, visit www.AmericanIndian.si.edu.

Smithsonian Books

Director: Carolyn Gleason
Senior Editor: Jaime Schwender
Assistant Editor: Julie Huggins
Copy Editor: Joanne Reams

National Museum of the American Indian

Publications Manager: Tanya Thrasher
Project Editor: Alexandra Harris
Senior Designer: Steve Bell
Designer: Nancy Bratton

Published in conjunction with the dedication of the National Native American Veterans Memorial on November 11, 2022.

Library of Congress Cataloging-in-Publication Data

Names: National Museum of the American Indian (Washington, DC), author.
Title: National Native American Veterans memorial : a souvenir book /
 National Museum of the American Indian.
Description: Washington, DC : National Museum of the American Indian,
 Smithsonian Institution, [2022]
Identifiers: LCCN 2022023363 | ISBN 9781588347183 (trade paperback)
Subjects: LCSH: National Native American Veterans' Memorial (Washington,
 DC)—Guidebooks. | National Native American Veterans' Memorial
 (Washington, DC)—Pictorial works. | Indian
 soldiers—Monuments—Washington (DC)—Pictorial works. | LCGFT:
 Illustrated works. | Guidebooks.
Classification: LCC E76.86.W3 N38 2022 | DDC
 725/.9409753—dc23/eng/20220615
LC record available at https://lccn.loc.gov/2022023363

Printed in Canada, not at government expense
26 25 24 23 22 1 2 3 4 5

Contents

Foreword vii
CYNTHIA CHAVEZ LAMAR

The Making of a Memorial 1
REBECCA HEAD TRAUTMANN

Memorial Designer and Veteran Harvey Pratt 14
ANNE BOLEN

Photo Gallery 18

Memorial Advisory Committee 51

Acknowledgments and Photo Credits 54

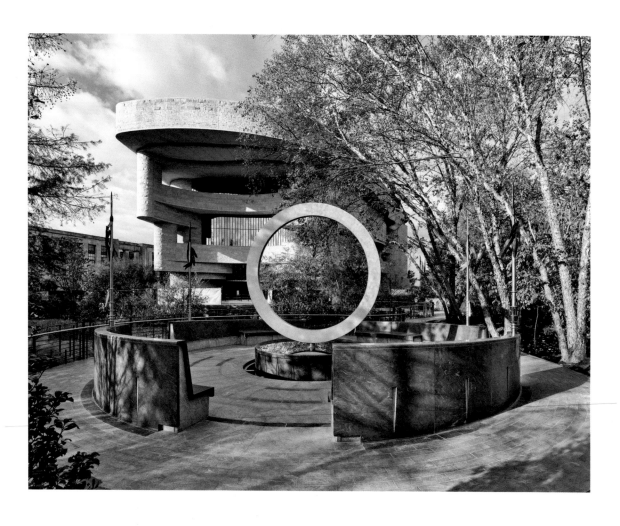

FOREWORD

CYNTHIA CHAVEZ LAMAR (SAN FELIPE PUEBLO/HOPI/TEWA/NAVAJO)
DIRECTOR, NATIONAL MUSEUM OF THE AMERICAN INDIAN

The National Native American Veterans Memorial opened on November 11, 2020, on the grounds of the Smithsonian's National Museum of the American Indian in Washington, DC. This tribute to Native service members recognizes for the first time on a national scale the enduring and distinguished service of Native Americans in every branch of the US armed forces.

Visually striking, the memorial's design by Harvey Pratt (Cheyenne and Arapaho Tribes of Oklahoma) creates an intimate space for gathering, remembrance, reflection, and healing. Nestled within the museum's landscape, the memorial features flowing water, spaces for offerings and blessings, seating for peaceful contemplation, and a central ring with a flame at the ring's base, which is visible during certain holidays and ceremonies. The memorial's simplicity is powerful, timeless, and inclusive—a place of learning and understanding for Native and non-Native visitors. It welcomes and honors American Indian, Alaska Native, and Native Hawaiian veterans and their families and reminds visitors that our nation's veterans have made extraordinary contributions throughout history.

Standing sentinel around the central ring are four stainless steel lances adorned with cast bronze feathers and battle streamers in red, yellow, white, and black—colors significant to many Native peoples. At the base of each lance, visitors can attach prayer cloths. As the cloths move in the wind, prayers are carried skyward.

Below: James Kivetoruk Moses (Inupiaq, 1901–1982), *Eskimo Celebration Dance at the End of World War II*, 1962. Paperboard, colored pencil, ink, watercolor. NMAI 26/2288

Right: Oglala Lakota veterans honoring quilt, 2008. Pine Ridge, South Dakota. Cotton and synthetic fabric, 167.4 x 166.2 cm. NMAI 26/7045

Creation of the memorial grew out of discussions with and feedback from Native people, particularly veterans and active-duty service members. From the start, the museum recognized that the memorial's development required input from those it would honor. Over the course of two years, NMAI staff spoke with Native American veterans, their family members, active-duty service members, and tribal leaders in thirty-five consultations across sixteen states and the District of Columbia. You can imagine how impactful these sessions were to the staff, who heard many stories of military service, including reasons for serving. As important, the people conveyed what values the memorial must embody: responsibility to protect life, acknowledgement of sacrifice, and reflection of Native spirituality.

The circle is a prominent design element of the memorial. The stainless-steel circle of the memorial represents cycles of time—the interconnectedness of the past, present, and future. Many tribal nations publicly recognize veterans and pay tribute to their sacrifice during cultural gatherings and powwows, often honoring generations of service within families. I invite you to learn more about the memorial's origins and significance by paging through this book or by visiting the museum in person.

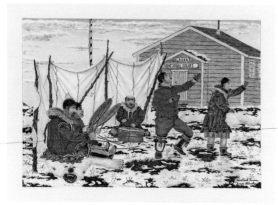

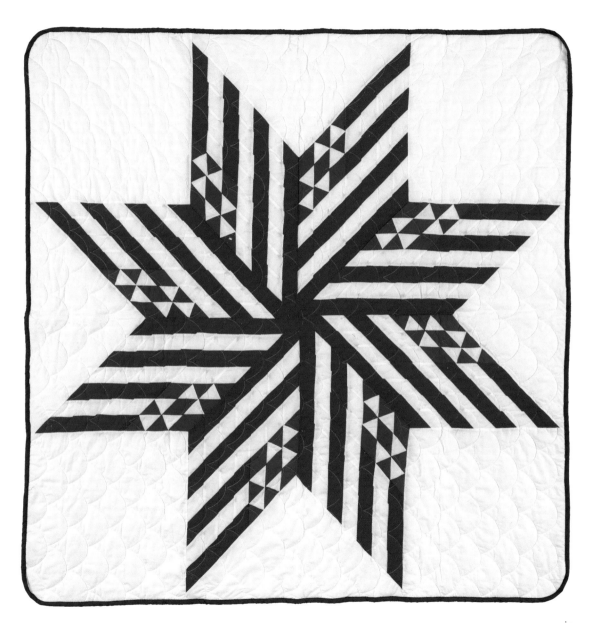

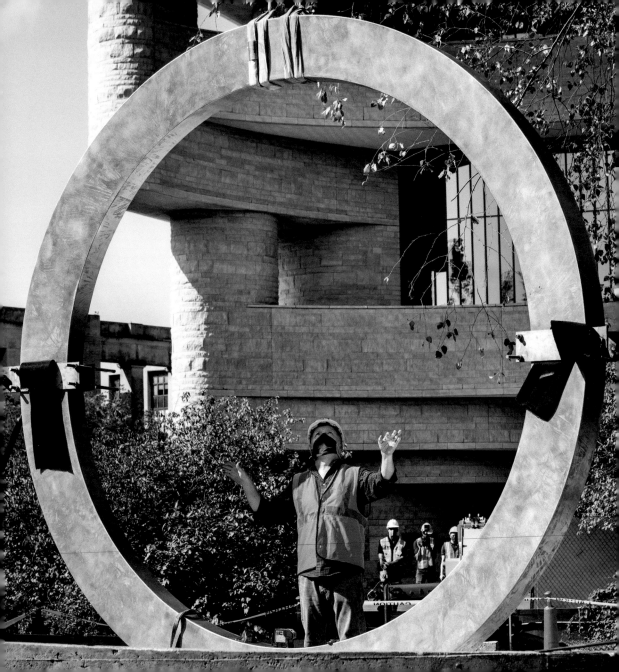

THE MAKING OF A MEMORIAL

A Long-Overdue Tribute to Native Veterans' Monumental Military Service

REBECCA HEAD TRAUTMANN

A memorial to honor Native veterans who have served in and out of combat has its roots centuries ago, when Indigenous people served on the battlefields of the Revolutionary War. American Indians have served in every major US military conflict since, often participating at an extraordinary rate. Today, more than 14,000 American Indian, Alaska Native, and Native Hawaiian service members are on active duty, and as of 2017, more than 140,000 veterans identify as American Indian or Alaska Native. Yet, while many Native communities deeply respect and honor their service

The National Native American Veterans Memorial is the first on the National Mall to recognize the service of American Indian, Alaska Native, and Native Hawaiian people in the United States Armed Forces. The memorial was designed by Harvey Pratt with Butzer Architects and Urbanism.

This memorial is saying: 'We are still here. We are still viable. We still count.'

—DEBRA KAY MOONEY (CHOCTAW)

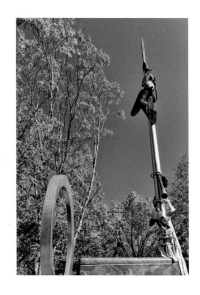

members, and veterans, their extraordinary service and sacrifices have rarely been acknowledged on a national level and are unknown to most other Americans.

"This memorial is saying: 'We are still here. We are still viable. We still count,'" says Debra Kay Mooney (Choctaw), who served on the memorial's Advisory Committee.

In 1994, in recognition of Native Americans' "long, proud and distinguished tradition of service in the Armed Forces of the United States," the United States Congress passed the Native American Veterans' Memorial Establishment Act. The legislation authorized the National Museum of the American Indian (NMAI) to create a memorial that would give "all Americans the opportunity to learn of the proud and courageous tradition of service of Native Americans in the Armed Forces of the United States."

This law—passed a decade before the museum opened on the National Mall in 2004—was amended in 2013, allowing for placement of the memorial on the grounds of the museum and enabling the project to begin. But that was just the first step. The museum knew this monument must be built with input from those it would honor.

REFLECTING THEIR STORY

Work on the National Native American Veterans Memorial began with the formation of an Advisory Committee of American Indian, Alaska Native, and Native Hawaiian veterans, tribal leaders, and families of veterans. The committee was cochaired by former Senator and Northern Cheyenne tribal member Ben Nighthorse Campbell and Chickasaw Nation Lt. Governor Emeritus Jefferson Keel, both distinguished veterans. The group grew to nearly thirty men and women who were from Native communities across the United States and represent all branches and several eras of service, from the Korean War to the present.

From 2015 to 2017, museum staff and members of the Advisory Committee spent about eighteen months consulting with Native American veterans, active duty service members, tribal leaders, veterans' families, and community members. During thirty-five consultations in sixteen states and the District of Columbia, staff met with about 1,200 people to share plans for the memorial and gather their recommendations.

The memorial must reflect life.
We were taught to love life, even to
the point of risking our lives to save
the life of another person.

—NELSON N. ANGAPAK SR. (YUP'IK), VETERAN

Jesse T. Hummingbird (Cherokee, 1952–2021), *Veterans*, 2016. Acrylic on canvas, 101.4 x 76 x 3.5 cm. NMAI 26/9780

Teri Greeves (Kiowa, b. 1970), *Prayer Blanket*, detail, 2006. Metal, silver, and glass beads; hawk bells; brain-tanned deer hide; cotton cloth; wool cloth; silk ribbon, 132 x 132 cm. NMAI 26/3325

Veterans and their family members told stories of service, sharing the pride and pain these memories bring them. Norma Jean Dunne (Tsimshian), who participated in one consultation session, wrote to the museum, "Our Native American and Alaska Native men and women have served in the United States Armed Forces with honor and distinction, defending the security of our nation and state of Alaska with their lives, whenever called upon."

Veterans also discussed their reasons for serving in the military, foremost among these being an inherited sense of responsibility to protect their homeland, family, community, and way of life. "Why are we willing to sacrifice our lives for this country?" Rod Grove (Southern Ute) posed. "Because our great-great-grandparents' bones are in this land."

These consultations with community members were essential to understanding what Native American veterans and their families

wish to see in the memorial, the values it must embody, and what the experience of visiting it should be. Several themes emerged that formed the basis of the memorial's design guidelines.

First, the memorial would need to be inclusive, honoring all American Indian, Alaska Native, and Native Hawaiian veterans, both men and women, from all branches and all eras of service. It should also respect the long tradition of service and the inherited responsibility to protect. "The memorial must reflect life," said Yup'ik veteran Nelson N. Angapak Sr. "We were taught to love life, even to the point of risking our lives to save the life of another person."

The memorial would also acknowledge the sacrifices made by the families of those who serve. As Commander Howard Richards of the Southern Ute Veterans Association said, "This memorial will represent all Native people, Native soldiers—men and women. [But] let's not forget the role that the families—mainly the women, the grandmas—played in this great history of ours."

Finally, it should reflect Native spirituality. Visiting the memorial should be a contemplative and healing experience— for veterans, families, and service members returning home. As Advisory Committee member Kevin P. Brown (Mohegan Tribe) said, "This is about the warrior, not the war."

INCLUSIVE, TIMELESS DESIGN

On Veterans Day in 2017, the museum launched an open competition to create a design for the memorial. The call drew 120 proposals from around the world. A jury of distinguished artists, architects, designers, cultural experts, and those representing veterans took great care in choosing five proposals

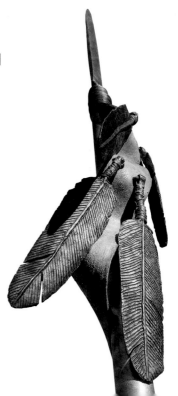

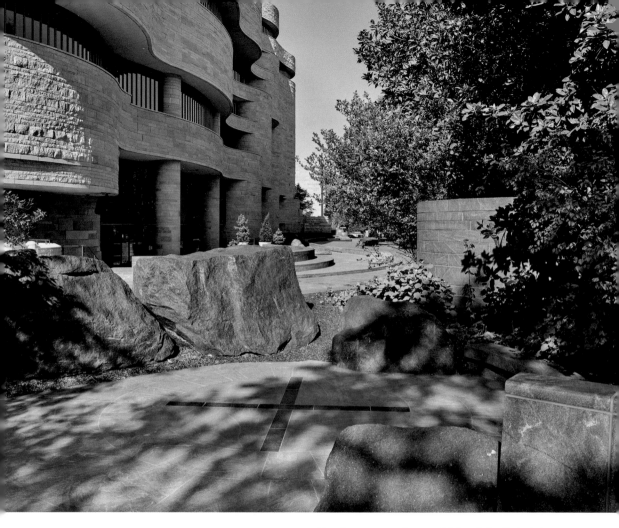

Near the entrance to the memorial, Grandfather Rocks shelter a private area for offering, prayer, and contemplation. Though not part of the memorial itself, the prayer circle's proximity echoes the memorial's themes of solace and remembrance. Around forty Grandfather Rocks— so called because the ancient rocks are the elders of the landscape— surround the National Museum of the American Indian.

blindly (indicated by their numbers only). The finalists were then asked to submit more detailed proposals, of which one concept stood out—that of Cheyenne and Arapaho artist and Vietnam veteran Harvey Pratt.

The centerpiece of Pratt's design is a vertical, twelve-foot-tall, stainless steel circle perched atop a low, carved stone drum. Water flows continuously from the center of the drum, and at the base of the circle, a fire can be lit on ceremonial occasions. Surrounding this "Warriors' Circle of Honor" is a circular seating area, which has four points of entry from the cardinal directions. This is one way the design accommodates the needs of different cultural practices, as members of different communities can enter the central space from the direction appropriate to their traditions.

Vanessa Jennings (Kiowa/Pima, b. 1952), Kiowa Battle Dress, ca. 2000. Rainbow selvage red and blue wool; hide thong; imitation elk teeth (bone); glass beads; brass beads, sequins, and bells; military patches; ribbons. NMAI 26/5646

This battle dress is similar to those worn by female relatives of warrior members of the Ton-Kon-Gah, or the Kiowa Black Leggings Society. The yellow patches with horse heads indicate a Vietnam War veteran from the army's First Cavalry.

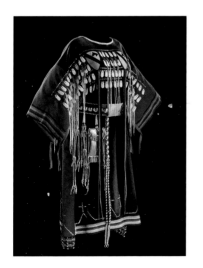

In our culture it is not proper for a man to brag about his war deeds. It is the woman's responsibility to dress and dance to honor him.

—VANESSA JENNINGS

Standing around the circular seating area are four lances, to which visitors can attach prayer cloths. Pratt says, "People can come in and say a prayer and tie those prayer cloths to those lances, and as the wind blows it, it shakes that prayer out again." He describes the stainless steel circle as representing "the hole in the sky where the Creator lives." On a nearby wall are the emblems of the five branches of the United States Armed Forces—the army, air force, coast guard, marine corps, and navy.

During the consultations, participants expressed a strong preference for a location in a quiet place on the grounds of the museum, rather than a more prominent, visible location near the busy streets of Washington, DC. So the memorial is set within the living landscape, at the edge of the upland hardwood forest and overlooking the freshwater wetland east of the museum.

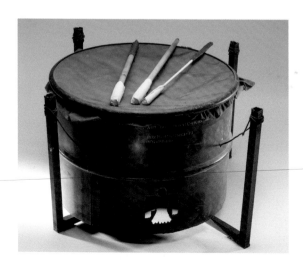

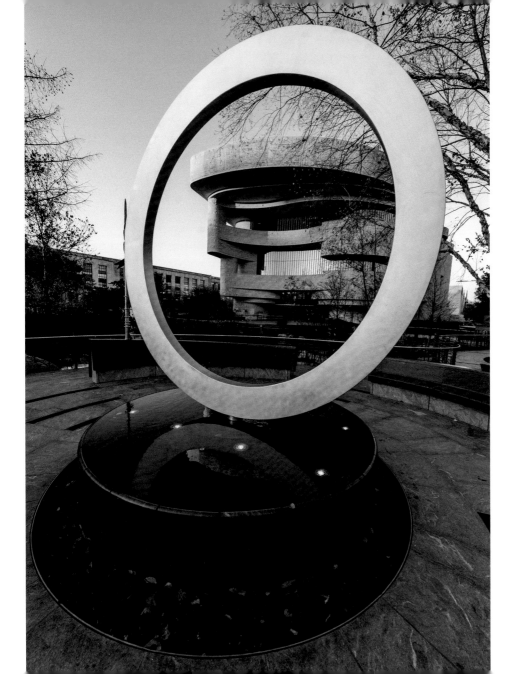

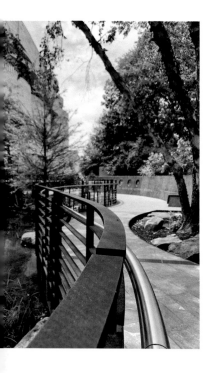

A meandering walkway leads visitors through the trees to the memorial, allowing them time to prepare themselves as they approach it. A circular Path of Life surrounds the memorial and the inner Path of Harmony. The trees and the water nearby help to buffer the memorial from the noise and traffic of the city.

Pratt's design for the memorial is simple, yet powerful and inclusive. The memorial incorporates the elements of fire, representing strength, courage, endurance, and comfort; water, signifying purification, prayer, and cleansing; earth, which provides people with all they need; and the wind that will carry the scents and sounds of the wetlands into the memorial site and carry the prayers and memories of visitors skyward. The design is open, yet it creates an intimate space for reflection or prayer.

The jury appreciated the circle's relevance to all Native American cultures, reflected in the shape of a drum and suggesting gatherings for dance, storytelling, and prayer. It evokes the cycles of time and life as well as the movement of the stars and planets. As the jurors noted in their review, Pratt's "concept of the circular nature of life makes individual veteran experiences and stories part of a collective, unified experience." And Pratt says, "the circle represents the unity and the timelessness of this design."

A PLACE TO HEAL

One of the most daunting challenges the museum faced in creating the National Native American Veterans Memorial was finding a design that would be truly inclusive of, and meaningful to, all Native American veterans. Pratt's design, informed and inspired by

his own experience as a veteran and tribal citizen who has lived this tradition of service, accomplishes this beautifully. The memorial is a welcoming space for reflection and remembrance, and for honoring the sacrifices and service of generations of Native veterans.

Pratt has expressed his desire to create a space that people will enter into rather than a statue or sculpture at which they can gaze. He says, "I want this to become a special, sacred place for people to come, a place for them to be healed." The water pulsing across the surface of the drum is echoed by concentric rings in the stone of the walkways, suggesting the beat of a drum calling people to the circle.

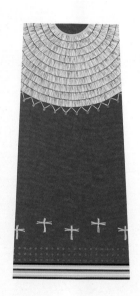

Dyani White Hawk (Sicangu Lakota, b. 1976), *Takes Care of Them*, 2019 (one of suite of four). Screenprint with metallic foil on paper, 55.5 x 32 cm each. NMAI 27/0636

Designed to honor Native American veterans, the memorial is also intended to educate non-Native visitors about their sacrifices. Pratt says this is part of its purpose, to welcome people "to come there and be respectful of our ways," adding, "Maybe this will help people see Native people and realize we're still here and very proud of this land." He also hopes this will give visitors a place to come to remember the veterans they have lost.

On November 11, 2022, the museum will host a celebration to mark the memorial's dedication. "This is a tremendously important effort to recognize Native Americans' service to this nation. We have so much to celebrate," says Campbell.

Rebecca Head Trautmann is the project curator for the National Native American Veterans Memorial and an assistant curator of contemporary art at NMAI.

Emil Her Many Horses (Oglala Lakota, b. 1954), *Honoring Our Lakota Vietnam Veterans*, 2002. Deer hide, glass beads, cotton, wool, synthetic fabric, wood, feathers.
NMAI 26/0604

Memorial Designer and Veteran Harvey Pratt

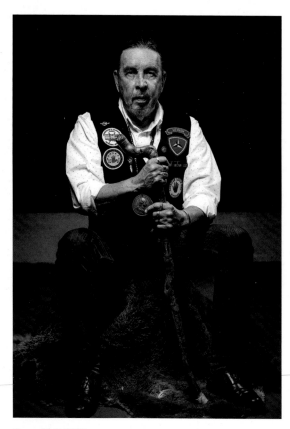

Harvey Pratt, 2019

Harvey Pratt, a member of the Cheyenne and Arapaho Tribes of Oklahoma and a United States Marine Corps veteran, almost didn't submit his winning design for the National Native American Veterans Memorial. In spite of the recognition he's earned for his artwork, he thought he would be outcompeted by the more than one hundred other artists and architects who participated.

But then, as he revealed in a fall 2020 interview, he was encouraged by another veteran and inspired by a dream. In the morning, he began to sketch a concept that would incorporate elements of wind, fire, water, and earth as well as unite all Native visitors "through ceremony and the spirituality of Native American people." Pratt says, "There are special places on this Earth that Indians go to, into the mountains and in the valleys. And so, I thought, you know, it has to be some place we go to. It has to be a destination."

Pratt brought his experience not only as a Native artist but as a marine to the table. Born in 1941, he grew up in El Reno, Oklahoma, a small town just west of Oklahoma City. He enlisted in 1962 and served in the Vietnam War as part of a unit assigned to protect troops and recover pilots who had been shot down.

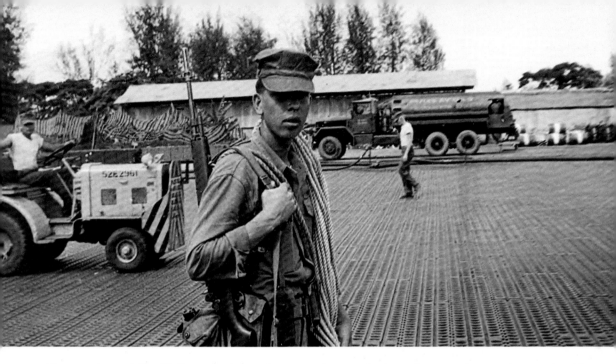

After returning to civilian life, Pratt served as a police officer for Oklahoma's Midwest City Police Department. There, he created his first witness description drawing, which led to an arrest and a conviction. In 1972, he joined the Oklahoma State Bureau of Investigation, working as an investigator, forensic artist, and eventually assistant director. As a forensic artist, he reconstructed faces of victims and culprits, aiding national and international law enforcement agencies in high profile cases such as the bombing of the Alfred P. Murrah Federal Building in Oklahoma City in 1995. Pratt retired in 2017 after more than fifty years in law enforcement.

Pratt still occasionally helps with cases and serves as a Cheyenne Peace Chief, but his full-time passion is his art.

He works in oil, acrylic, watercolors, metal, clay, and wood. Among his favorite topics are "history, tradition, truthfulness, tribulation, and humanity's essence." Such themes are clearly reflected in his exceptional memorial design.

Anne Bolen is the assistant managing editor of *American Indian* magazine at the National Museum of the American Indian.

Harvey Pratt stands on the airfield at Da Nang on his last day of service in Vietnam, in 1963. He carries the rappelling rope he used to descend from helicopters to clear landing fields, as well as an M-14 and grenades.

Jim Yellowhawk (Minneconjou Lakota/
Iroquois, b. 1958), *Lakota Horse Mask*, 2008.
Acrylic paint and gold leaf on paper, 80.5 x
56.7 cm. NMAI 26/7199

Why are we willing to sacrifice our lives for this country? Because our great-great-grandparents' bones are in this land.

—ROD GROVE (SOUTHERN UTE), CONSULTING COMMUNITY MEMBER

Embedded within the walls of the memorial are the emblems of the five branches of the United States Armed Forces: the army, air force, coast guard, marine corps, and navy.

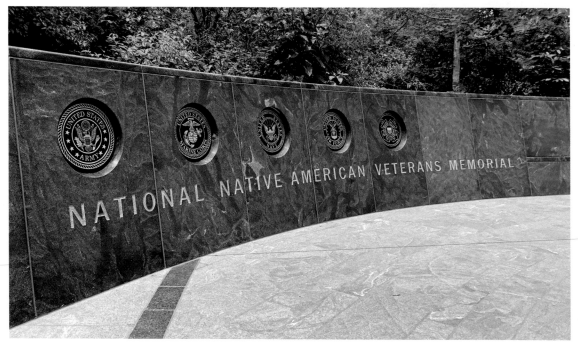

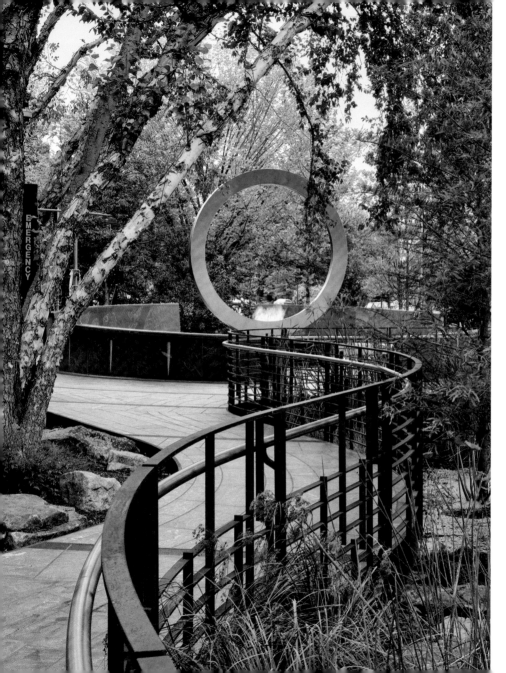

A flame will be lit at the base of the circle to mark ceremonial occasions. Evoking the element of fire, the flame represents strength, courage, endurance, and comfort.

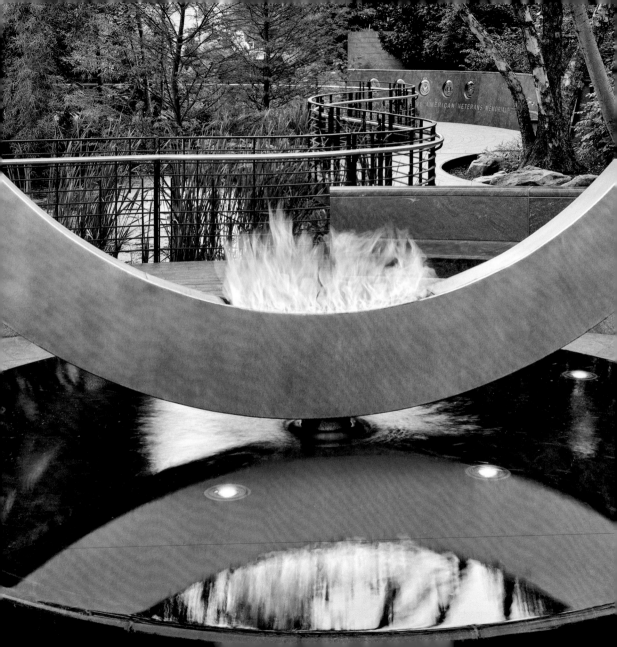

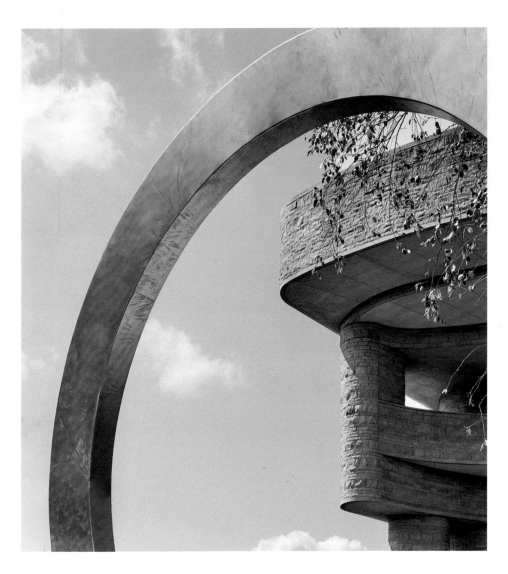

The memorial brings together the four
elements: earth, air, fire, and water.

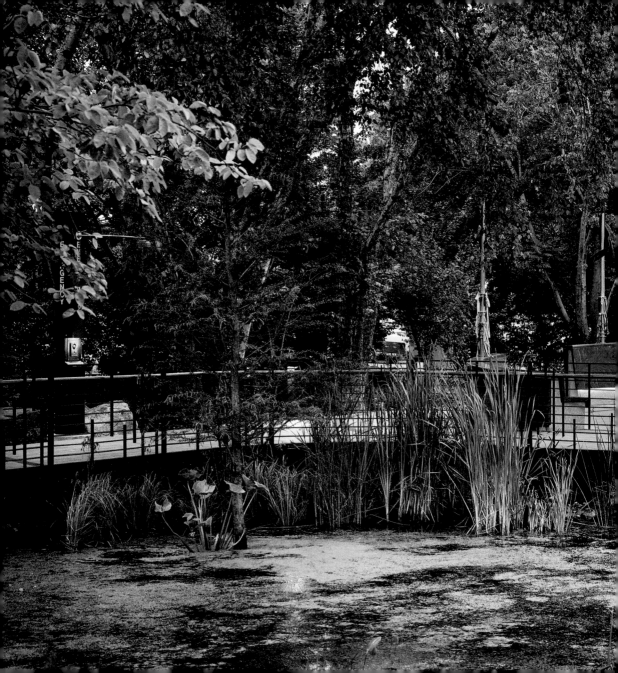

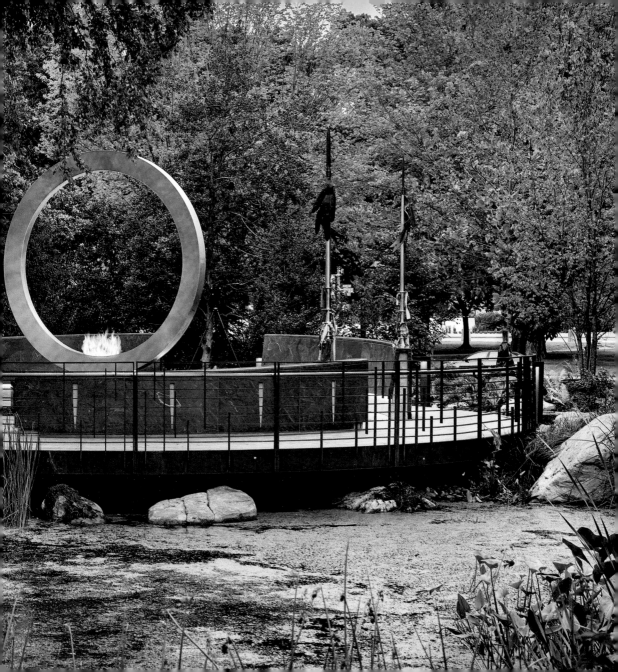

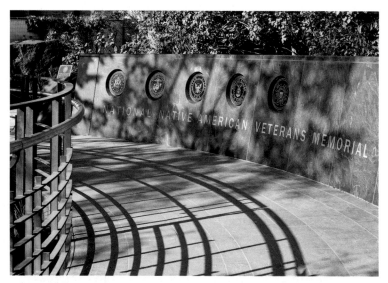

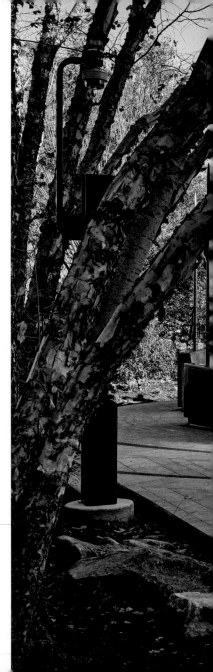

The central symbol of the memorial is a twelve-foot-tall stainless steel circle, representing an opening to the spiritual world. According to designer Harvey Pratt, the air that moves through the memorial passes through the circle and carries visitors' prayers to the Creator. The circle is a widespread symbol in Indigenous cultures. "Everything that we have as a tribal people honors the circle," says Pratt. "Tipis and kivas are round. Earth lodges and igloos are round. Indian people have always seen the circle in the sun and the moon. We've seen it in the weather, the seasons, and the cycle of life. It is continuous and timeless." Thus the circle is a repeated design element in the memorial.

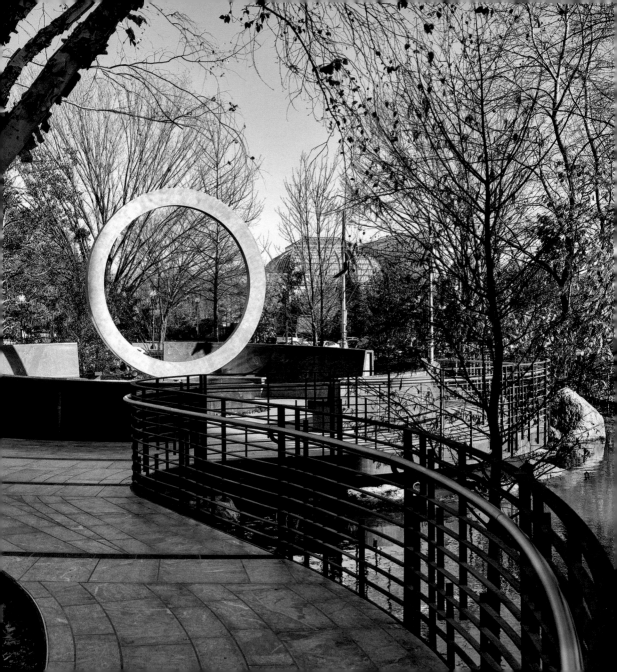

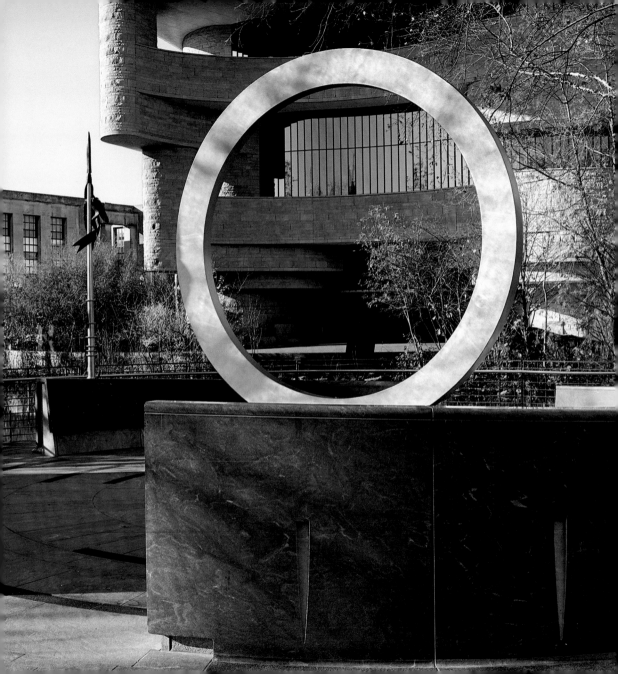

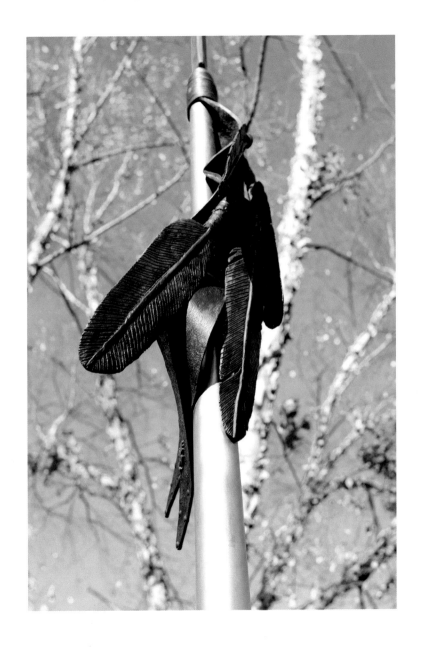

27

This is a tremendously important effort to recognize Native Americans' service to this nation. We have so much to celebrate.

—BEN NIGHTHORSE CAMPBELL (NORTHERN CHEYENNE)

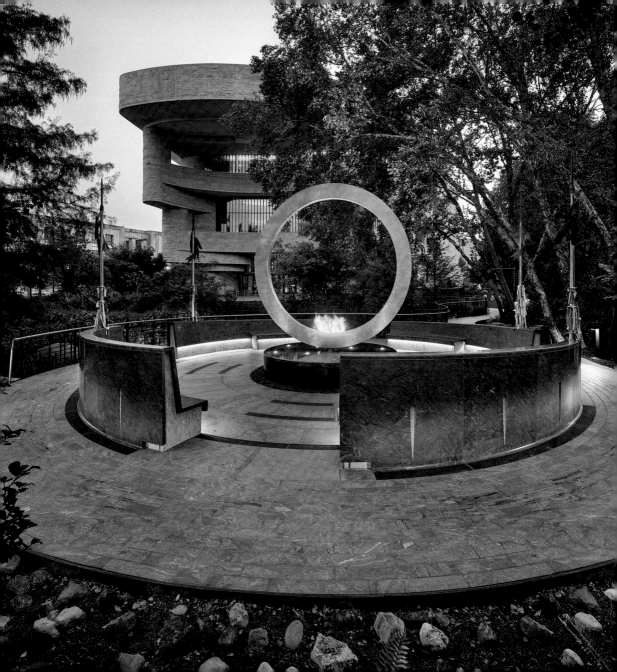

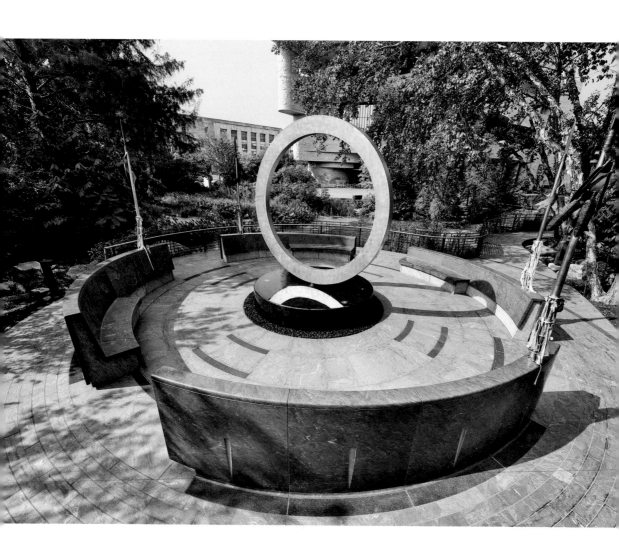

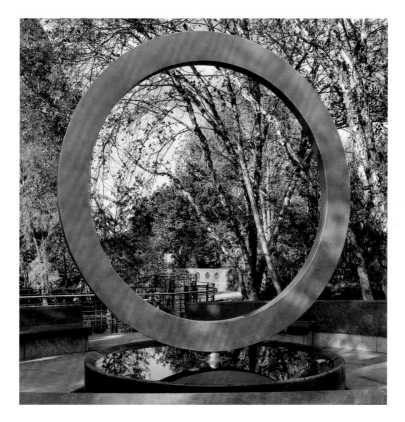

The outer circle that surrounds the memorial is called the Path of Life. The area encircling the central drum and ring is called the Path of Harmony, which is accessed through one of four openings corresponding to the cardinal direction points: north, south, east, and west. This allows Native people to enter and exit this area according to their ceremonial traditions. The paths, walls, and seating area represent the element of earth, which provides people with everything they require for life.

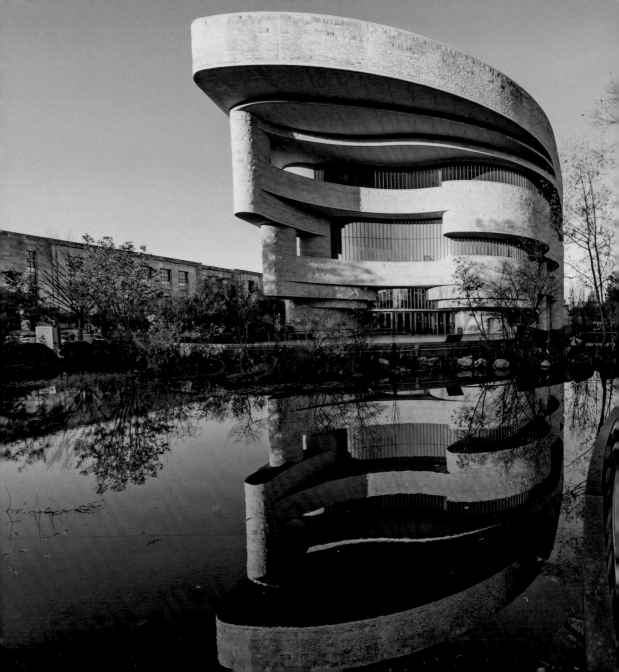

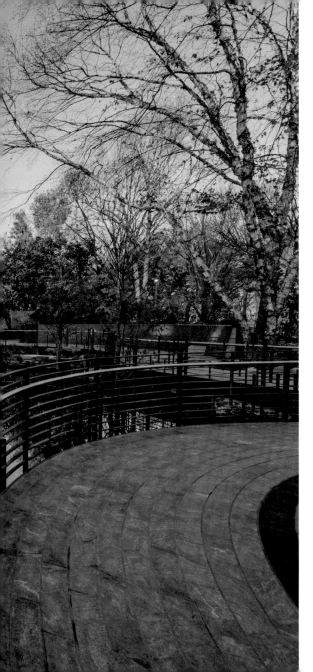

The National Native American Veterans Memorial stands within the living landscape of the National Museum of the American Indian. Native veterans expressed a desire for the memorial to be a quiet place for prayer and reflection. The surrounding freshwater wetlands separate it from the noise of the city.

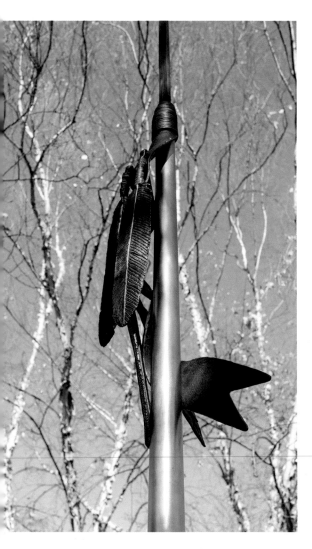

People can come in and say a prayer and tie those prayer cloths to those lances, and as the wind blows it, it shakes that prayer out again.

—HARVEY PRATT (CHEYENNE/ARAPAHO), ARTIST AND VIETNAM VETERAN

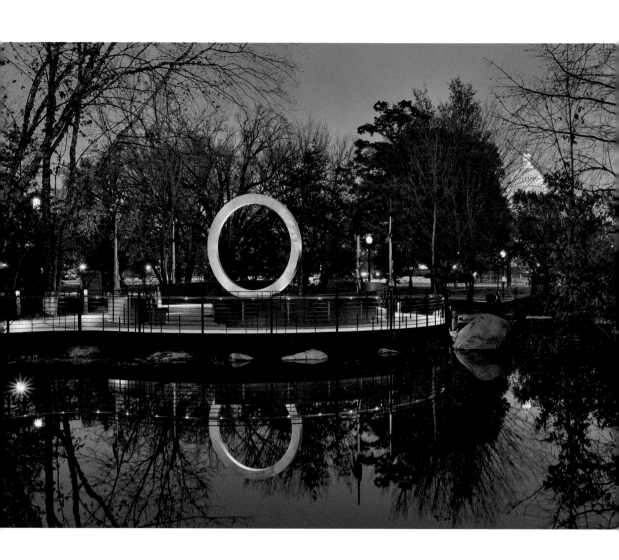

I want this to become a special, sacred place for people to come, a place for them to be healed.

—HARVEY PRATT (CHEYENNE/ARAPAHO), ARTIST AND VIETNAM VETERAN

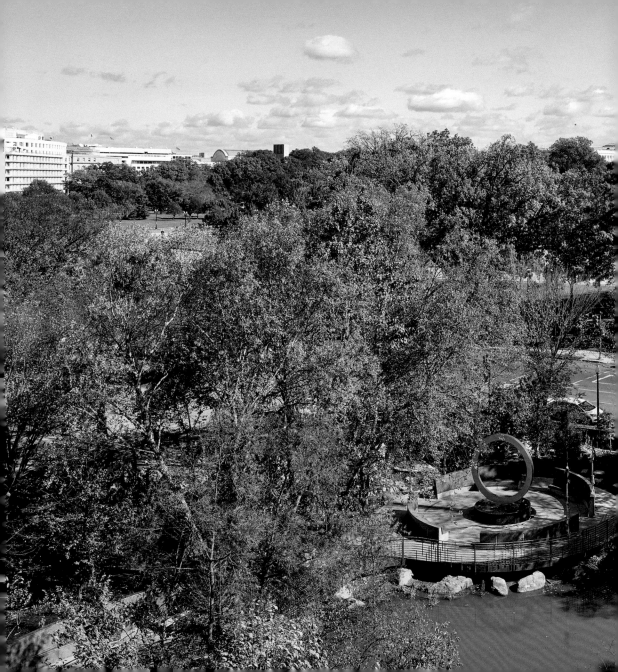

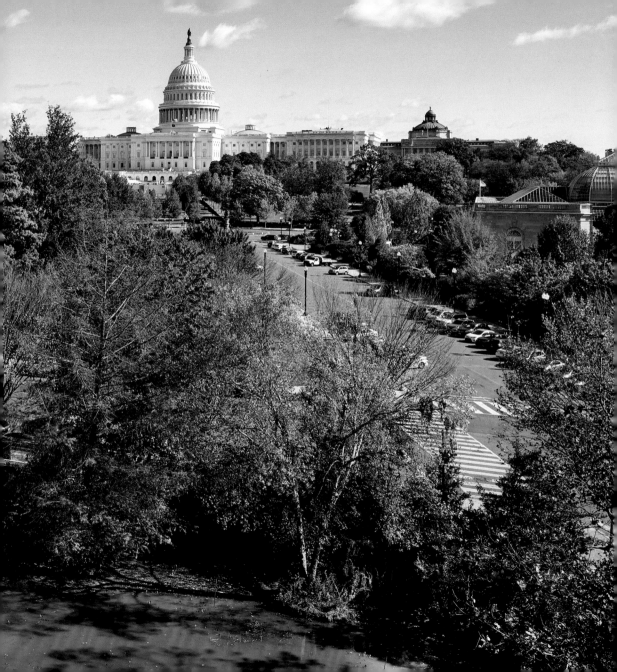

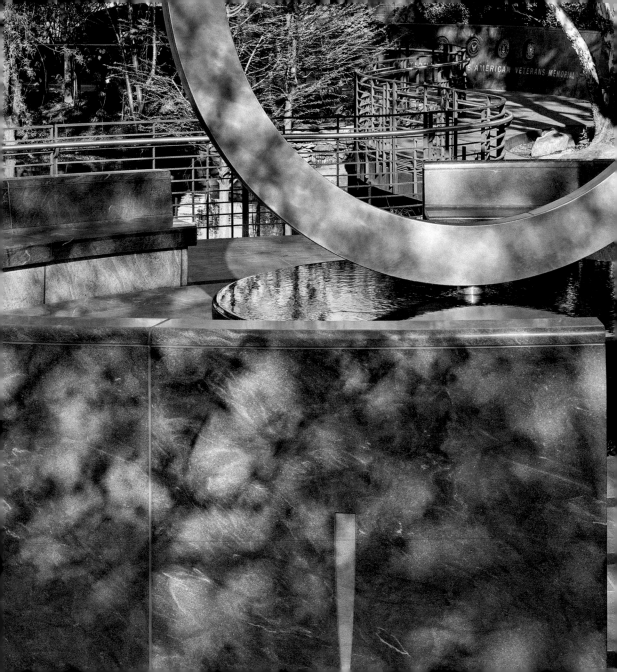

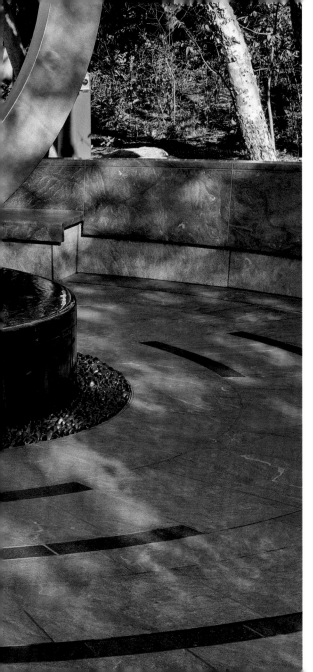

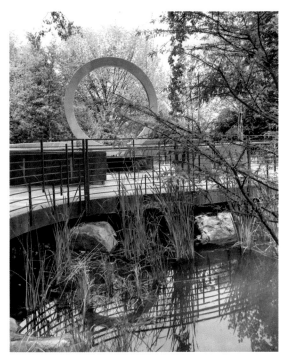

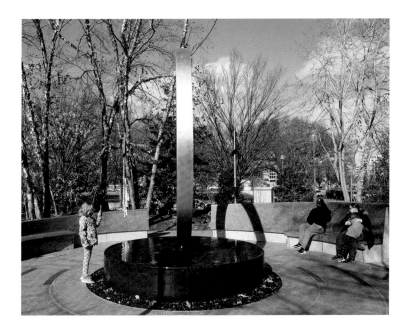

The design of the memorial is meant to be inclusive, honoring and reflecting all Indigenous traditions and acknowledging an inherited responsibility to protect Native communities and lands. The memorial also recognizes the sacrifices made by the families of those who serve and exists as a place for healing and contemplation for all.

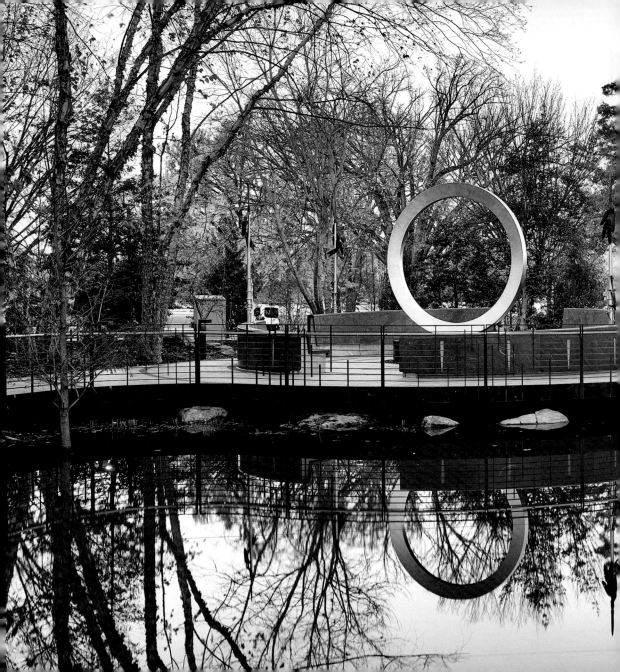

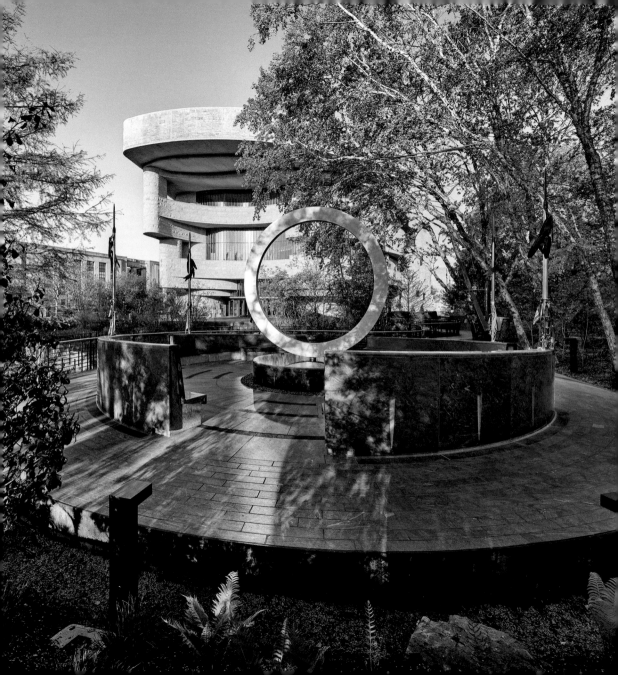

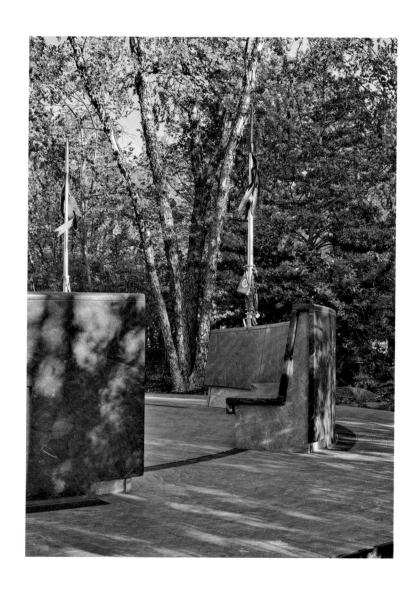

This is about the warrior, not the war.

—KEVIN P. BROWN (MOHEGAN TRIBE), ADVISORY COMMITTEE MEMBER

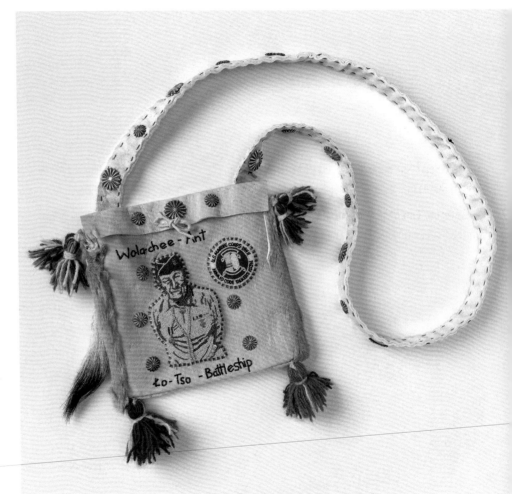

J.T. Willie
(Diné [Navajo],
*Diné Bizaad yee
Nidaazbaa'igíí
(A Tribute to Our
Navajo Code
Talkers)*, 2015. Deer
hide and tail; glass,
turquoise, and
gold beads; metal
conchas, wool yarn,
and dyes, 38.0
x 33.0 x 5.5 cm;
102.5 cm w/strap.
26/9693

ADVISORY COMMITTEE

COCHAIRS

Senator Ben Nighthorse Campbell (Northern Cheyenne)
United States Air Force

Lt. Governor Emeritus Jefferson Keel (Chickasaw Nation)
United States Army

ADVISORY COMMITTEE MEMBERS

Mark Azure (Fort Belknap, Assiniboine)
United States Army

Mitchelene BigMan (Crow/Hidatsa)
United States Army

Kurt V. BlueDog (1950–2020) (Sisseton Wahpeton Oyate)
United States Army

Johancharles "Chuck" Van Boers (Lipan Apache)
United States Army

Stephen D. Bowers (1949–2020)
(Seminole Tribe of Florida)
United States Army

Kevin P. Brown (Mohegan Tribe)
United States Army

James Chastain Sr. (Lumbee)
United States Army

Debora Coxe (Mackinac Tribe of Odawa and
Ojibwe Indians)
Gold Star Mother

S. Joe Crittenden (Cherokee Nation)
United States Navy

Gerald L. Danforth Sr. (Oneida Nation)
United States Navy

Col. Wayne W. Don (Cup'ig/Yup'ik)
United States Army, Alaska Army National Guard

John Emhoolah (1929–2021) (Kiowa)
United States Army

Marshall Gover (1946–2019) (Pawnee)
United States Marine Corps

Gary Hayes (Ute Mountain Ute Tribe)
United States Navy

Manaja Hill (Standing Rock Sioux Tribe)
United States Army

Allen K. Hoe (Native Hawaiian)
United States Army, Gold Star Father

Rear Admiral Michael L. Holmes, Retired (Lumbee)
United States Navy

Judge Sharon House (Oneida Nation)
Military Family

Earl Howe III (Ponca Tribe of Oklahoma)
United States Army

Lee Gordon McLester III (1939–2020) (Oneida Nation)
United States Marine Corps Reserves

Chairman Arlan D. Melendez (Reno Sparks Indian Colony)
United States Marine Corps

Debra Kay Mooney (Choctaw)
United States Army

Nancy Tsoodle Moser (Kiowa)
Military Family, United States Coast Guard Civilian

Elaine Peters (Ak-Chin)
United States Marine Corps

Principal Chief Richard Sneed (Eastern Band
of Cherokee Indians)
United States Marine Corps

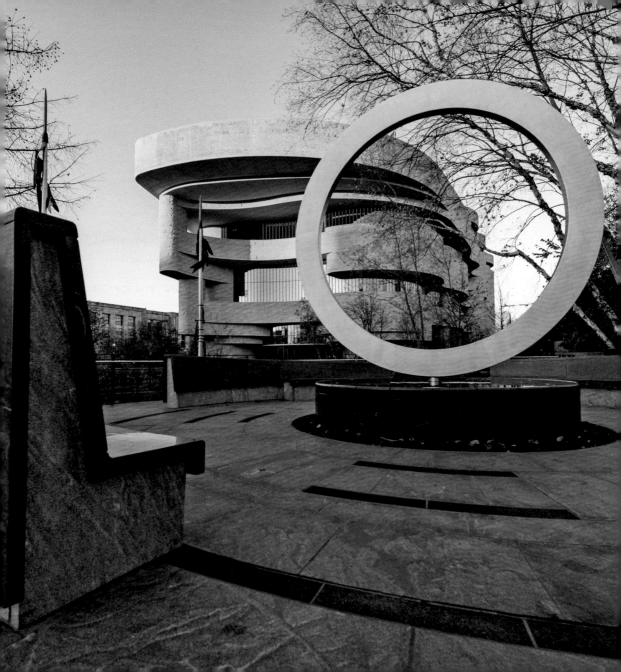

ACKNOWLEDGMENTS

The Smithsonian's National Museum of the American Indian gratefully acknowledges individuals, organizations, and Native nations for their generosity and commitment to the National Native American Veterans Memorial.